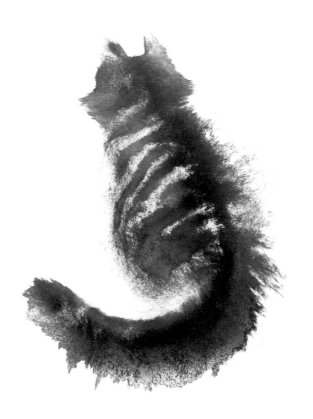

MAMMALS

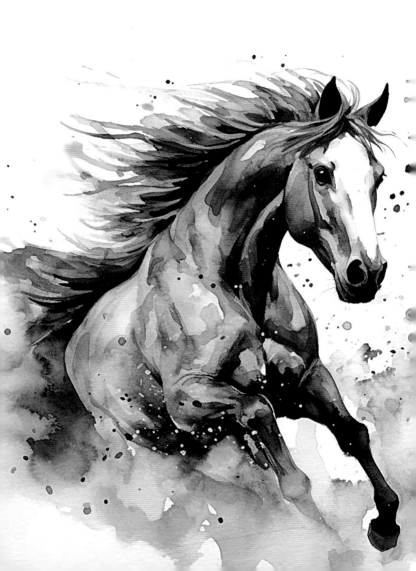

Mammals

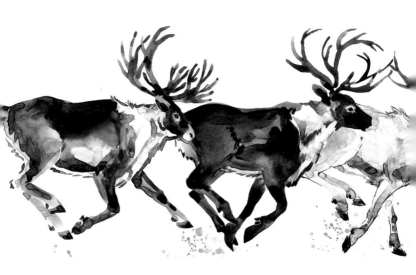

Mammals

Over hundreds of millions of years mammals have evolved to fill almost every ecological niche on the planet, from inhospitable Arctic and desert conditions to dense forests and ocean depths. With this diversity have come myriad forms, with more than six thousand mammal species in existence today. These range from mighty whales and elephants, to tiny mice and shrews, to bats in the skies, and not

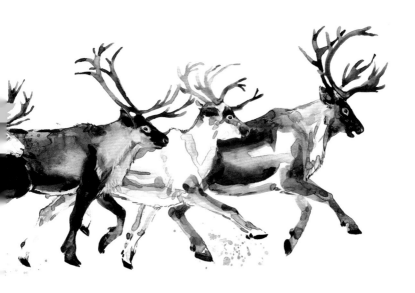

forgetting ourselves – humans – from the equation.

This book is a celebration of mammals, from large carnivores such as tigers and wolves to the many weird and wonderful varieties, including giraffes, platypuses, anteaters and aye-ayes. Beautiful watercolours and other artworks are coupled with quotes – some thought-provoking or inspiring, others funny or just downright silly – to make a volume that any nature lover will want to dip into again and again.

"How many legs does a dog have if you call his tail a leg? Four. Saying that a tail is a leg doesn't make it a leg."

– ABRAHAM LINCOLN

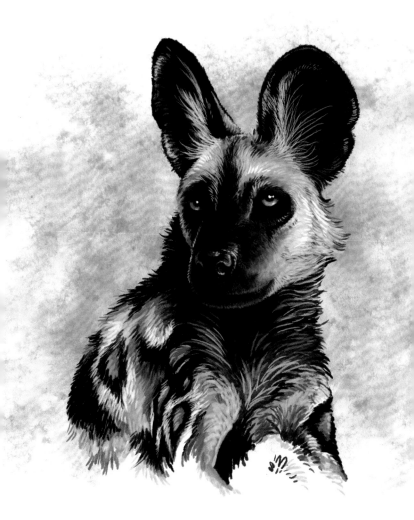

"*There's nothing better than just staring at a buttercup, struggling to make an impact on the world.*"

– BOB MORTIMER

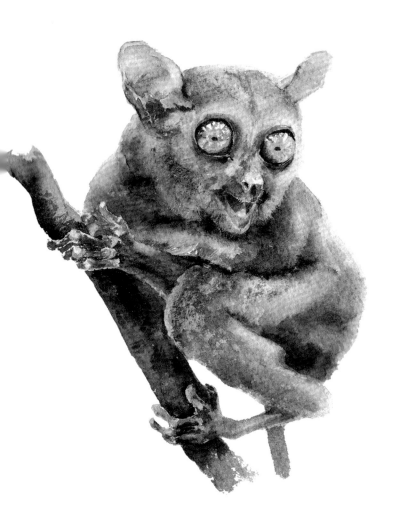

"*If I believed a giant Platypus was coming to liberate humanity and save us all, it would still make more sense than the climate denial people do.*"

– STEVE MERRICK

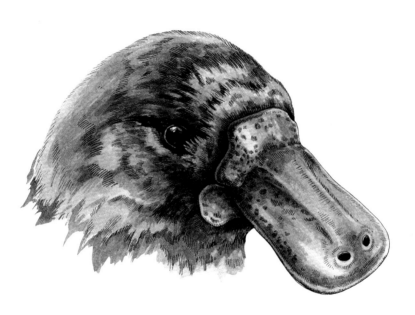

"*The best relationship you can have with a chimpanzee is total mutual trust.*"

– JANE GOODALL

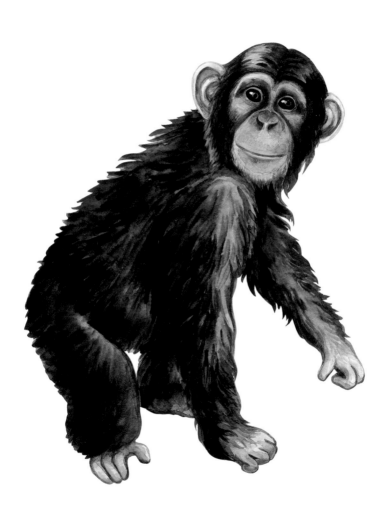

"You don't choose your family. They are God's gift to you, as you are to them."

– DESMOND TUTU

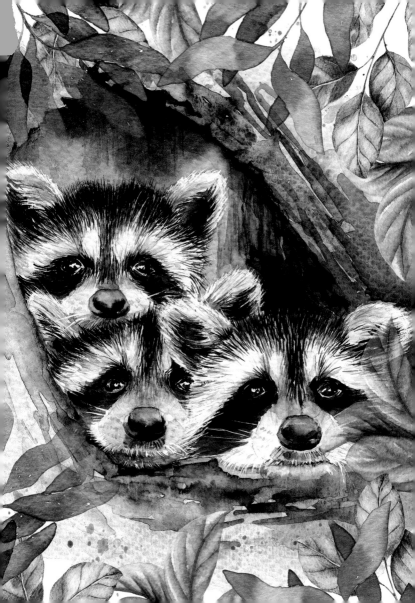

"Like as the waves make towards the pebbl'd shore, so do our minutes, hasten to their end."

– WILLIAM SHAKESPEARE

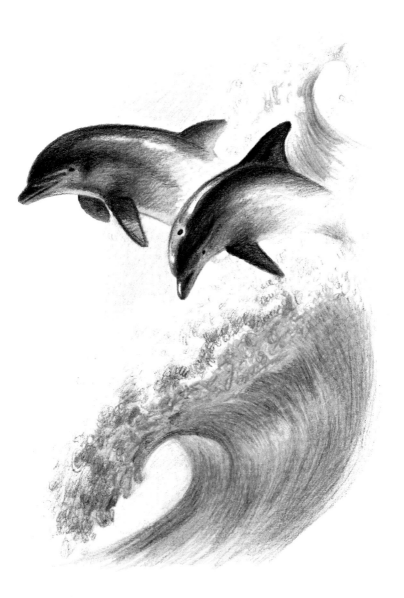

"We are all travellers
in the wilderness of this
world, and the best we
can find in our travels is
an honest friend."

– ROBERT LOUIS STEVENSON

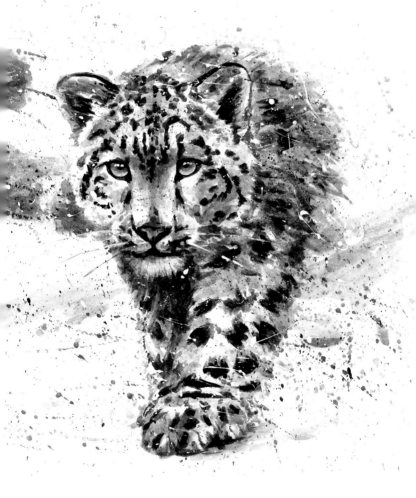

"The home to everyone is to him his castle and fortress, as well for his defence against injury and violence, as for his repose."

– EDWARD COKE

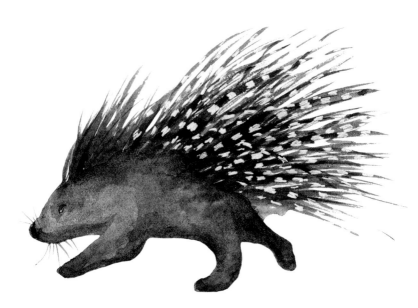

"*People's dreams are made out of what they do all day. The same way a dog that runs after rabbits will dream of rabbits. It's what you do that makes your soul, not the other way around.*"

– BARBARA KINGSOLVER

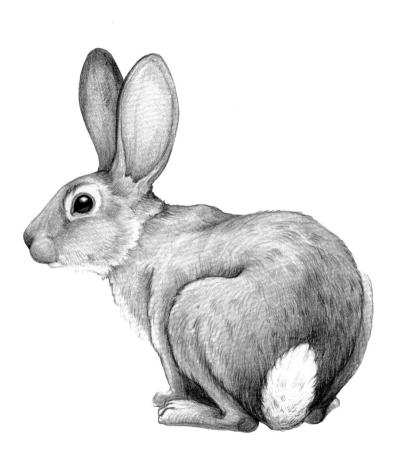

"Character cannot be developed in ease and quiet. Only through experience of trial and suffering can the soul be strengthened, ambition inspired, and success achieved."

– HELEN KELLER

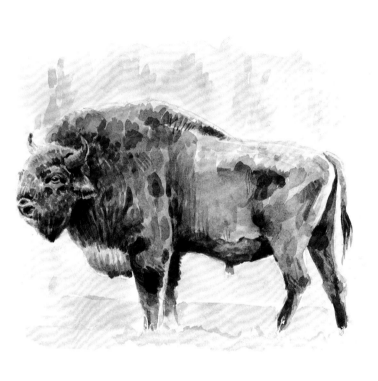

"It is not enough to be busy.
So are the ants.
The question is:
What are we busy about?"

– HENRY DAVID THOREAU

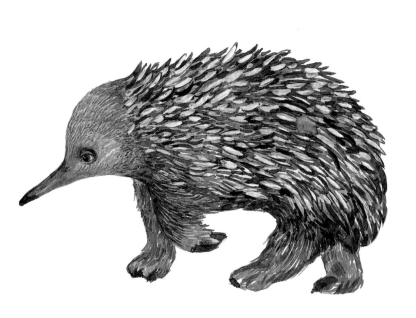

*"I am a born hunter,
like my father,
my grandfather,
and every man of my
family before them."*

– ROBERTO BAGGIO

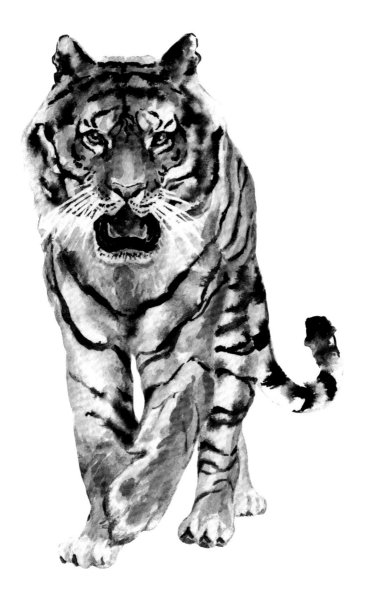

"It is better to conquer
yourself than to win a
thousand battles. Then the

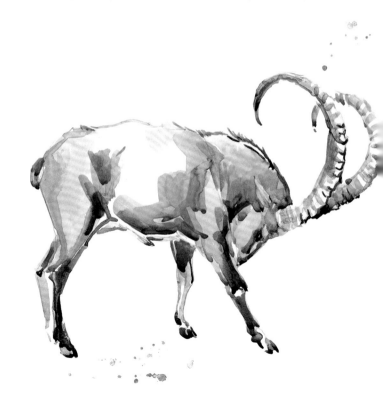

victory is yours. It cannot be taken from you, not by angels or by demons, heaven or hell."

– BUDDHA

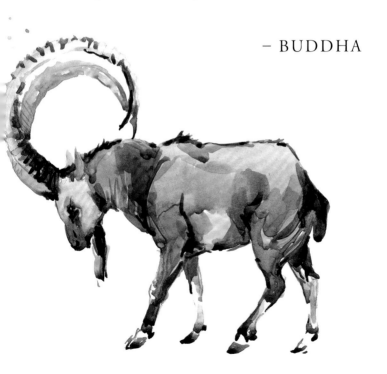

"Loneliness adds beauty to life. It puts a special burn on sunsets and makes night air smell better."

– HENRY ROLLINS

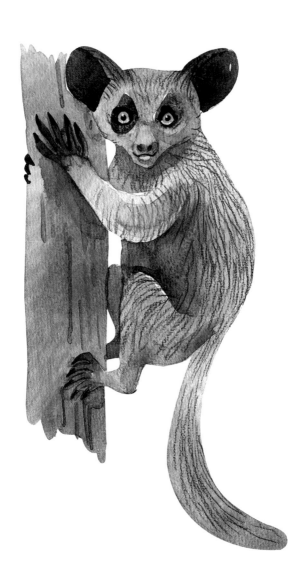

"The only way to save a rhinoceros is to save the environment in which it lives, because there's a mutual dependency between it and millions of other species of both animals and plants."

– DAVID ATTENBOROUGH

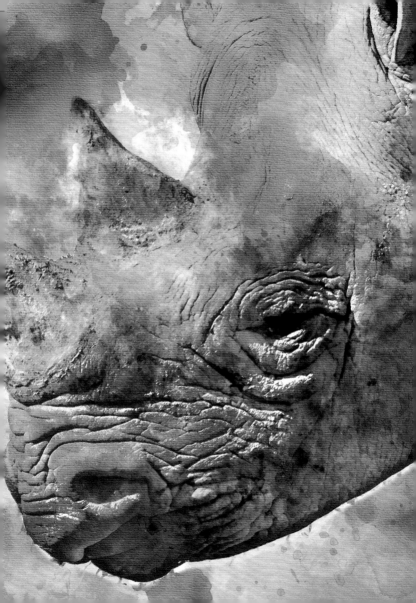

"*Nothing doth more hurt in a state than that cunning men pass for wise.*"

– FRANCIS BACON

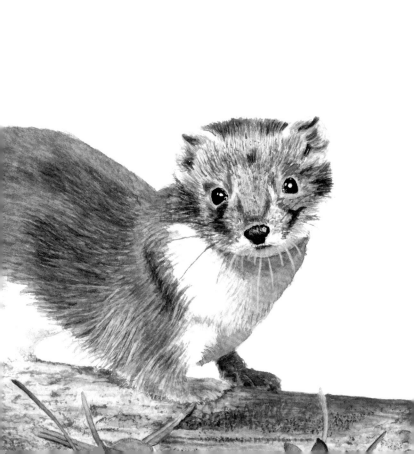

"*I was the shyest human ever invented, but I had a lion inside me that wouldn't shut up!*"

– INGRID BERGMAN

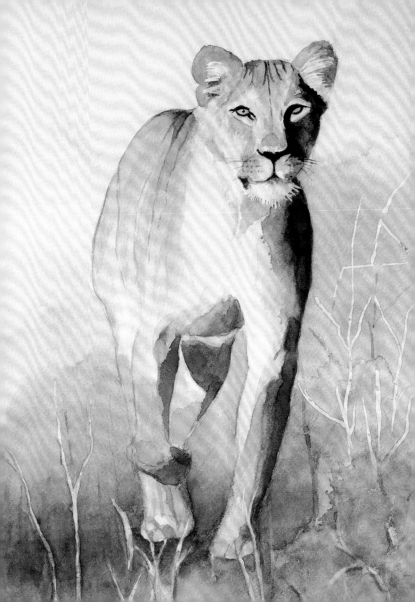

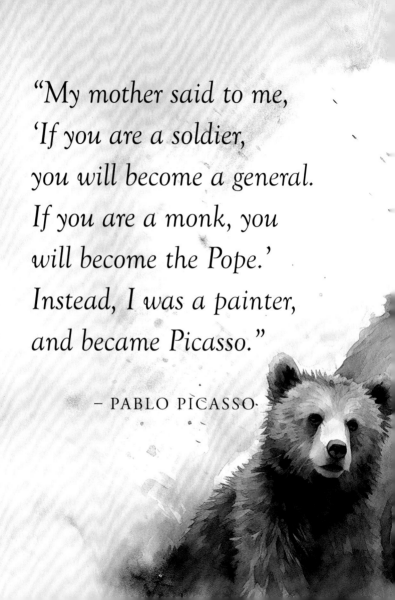

"My mother said to me,
'If you are a soldier,
you will become a general.
If you are a monk, you
will become the Pope.'
Instead, I was a painter,
and became Picasso."

– PABLO PICASSO

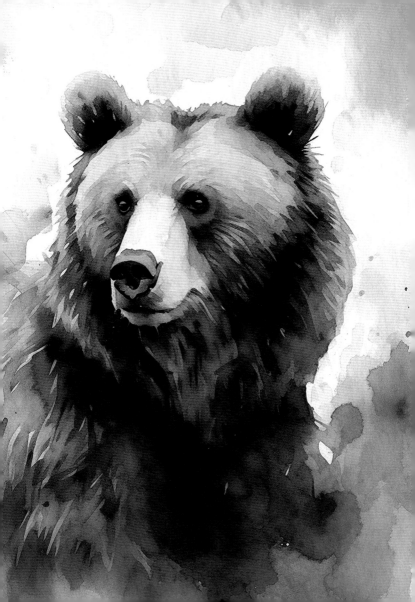

"When you hear that howl alone at night in the forest, it's one of the most frightening sounds you'll ever hear."

– TIM COPE

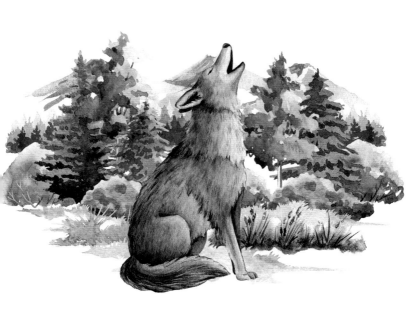

"If you aren't in over your head, how do you know how tall you are?"

– T. S. ELIOT

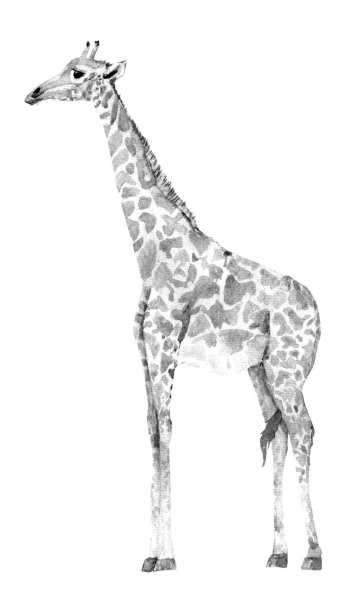

*"Looking back at
my life's voyage,
I can only say that
it has been a golden trip."*

– GINGER ROGERS

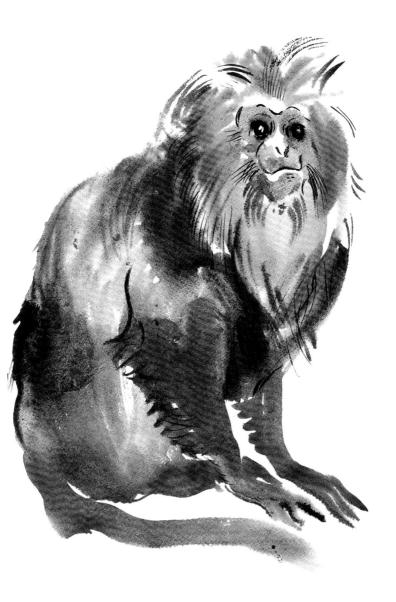

"Nothing is more musical than a sunset. He who feels what he sees will find no more beautiful example of development in all that book which, alas, musicians read but too little – the book of Nature."

– CLAUDE DEBUSSY

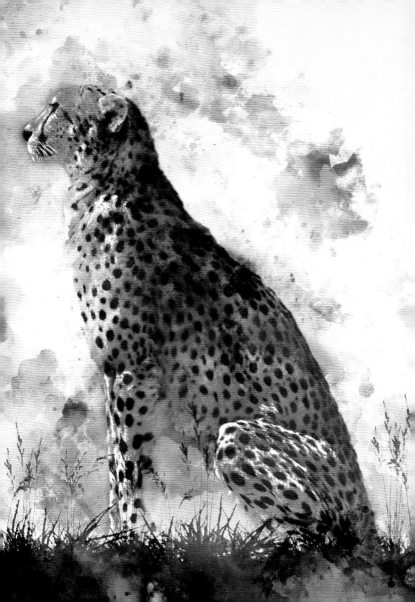

"I am good, but not an angel.
I do sin, but I am not the
devil. I am just a small girl
in a big world trying to find
someone to love."

– MARILYN MONROE

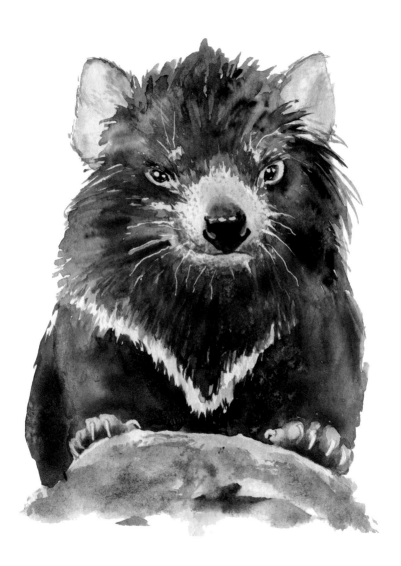

"The woods are lovely,
dark and deep.
But I have promises to keep,
and miles to go
before I sleep."

– ROBERT FROST

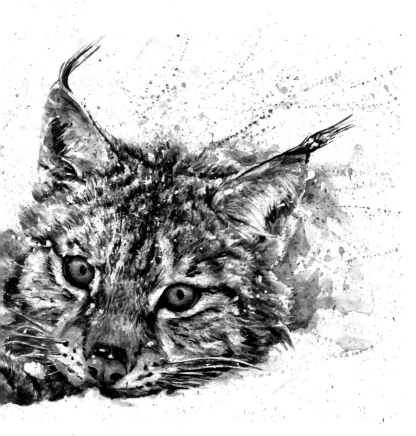

"I am sometimes a fox and sometimes a lion. The whole secret of government lies in knowing when to be the one or the other."

– NAPOLEON BONAPARTE

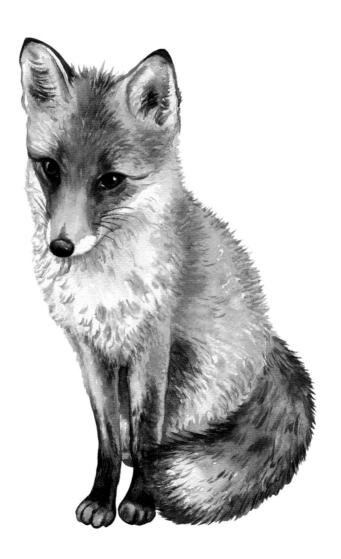

"Do not be in a hurry to rush into the pleasures of the world, like the young antelope who danced herself lame when the main dance was yet to come."

– CHINUA ACHEBE

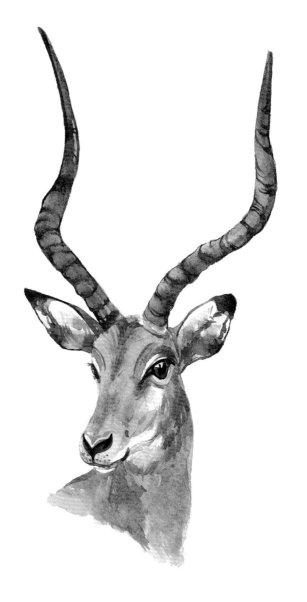

"I asked the Zebra,
are you black
with white stripes?
Or white with black stripes?
And the zebra asked me,
Are you good with bad habits?
Or are you bad
with good habits?"

– SHEL SILVERSTEIN

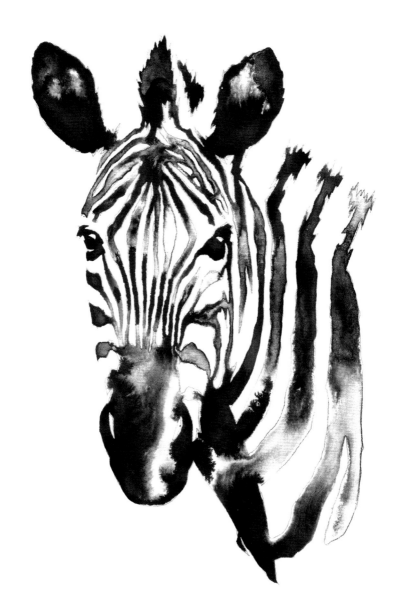

"Bats drink on the wing, like swallows, by sipping the surface, as they play over pools and streams."

– GILBERT WHITE

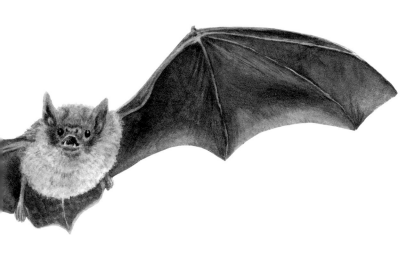

"A leopard does not change
his spots, or change his feeling
that spots are rather a credit."

– IVY COMPTON-BURNETT

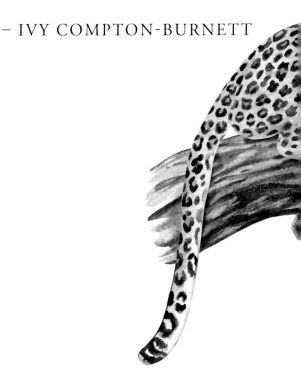

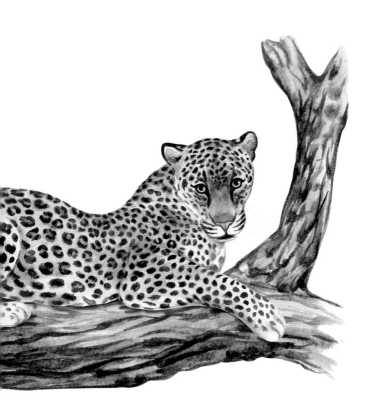

"*Destroying a tropical rainforest for profit is like burning all the paintings of the Louvre to cook dinner.*"

– E. O. WILSON

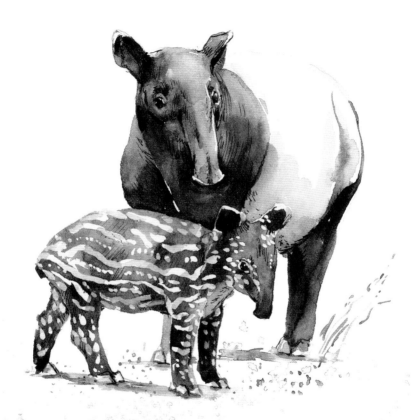

"Writers are a little below clowns and a little above trained seals."

– JOHN STEINBECK

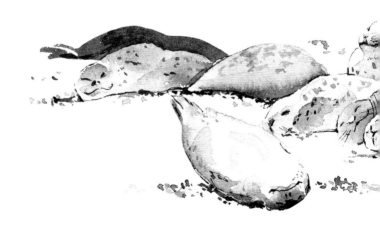

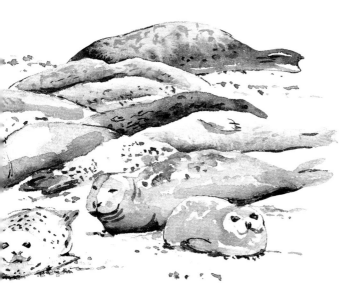

"*Once you appreciate one of your blessings, one of your senses, your sense of hearing, then you begin to respect the sense of seeing and touching and tasting, you learn to respect all the senses.*"

– MAYA ANGELOU

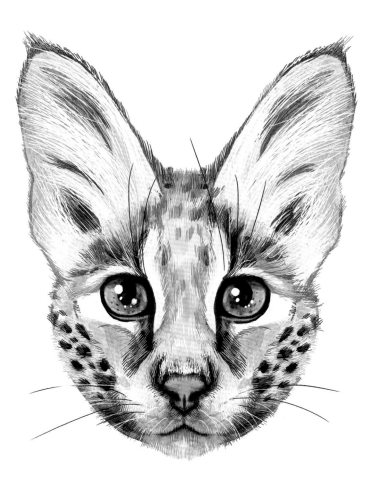

"God bless America.
God save the Queen.
God defend New Zealand.
And thank Christ
for Australia."

– RUSSELL CROWE

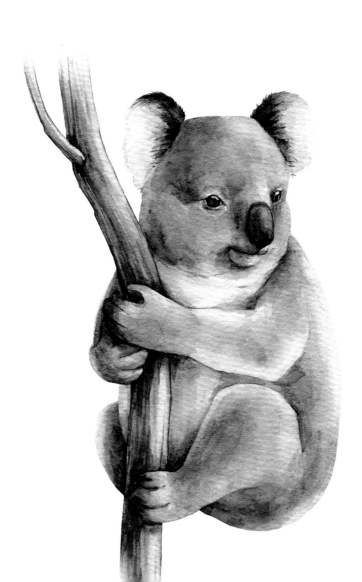

"*If we had a keen vision of all that is ordinary in human life, it would be like hearing the grass grow or the squirrel's heart beat, and we should die of that roar which is the other side of silence.*"

– GEORGE ELIOT

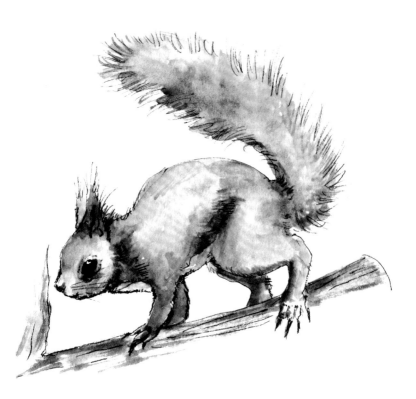

"Evolution is a snail, but Revolution is a kangaroo; one crawls, the other jumps!"

– MEHMET MURAT ILDAN

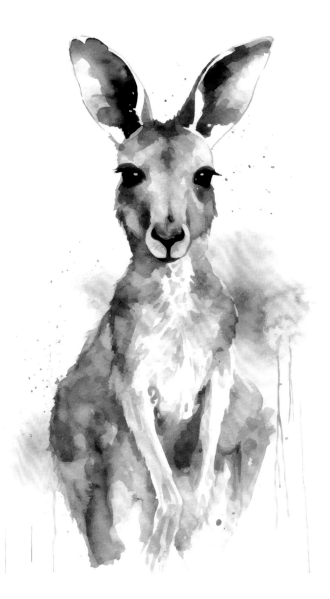

"*The eyes are more exact witnesses than the ears.*"

– HERACLITUS

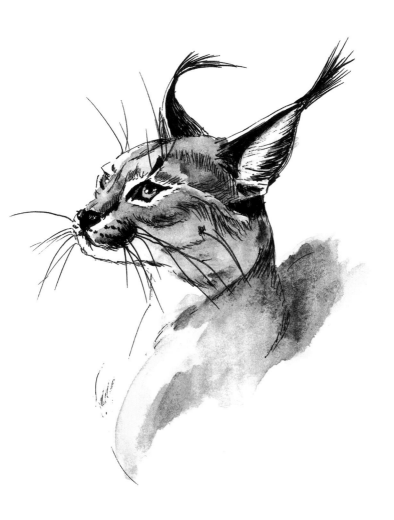

"We owe it to our children to be better stewards of the environment. The alternative

– a world without whales –
is too terrible to imagine."

– PIERCE BROSNAN

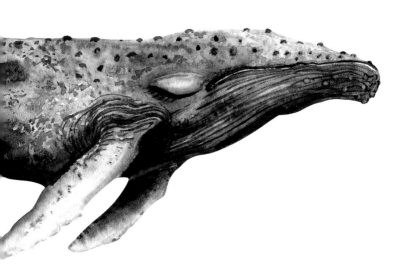

"*The fox has many tricks.
The hedgehog has but one.
But that is the best of all.*"

– RALPH WALDO EMERSON

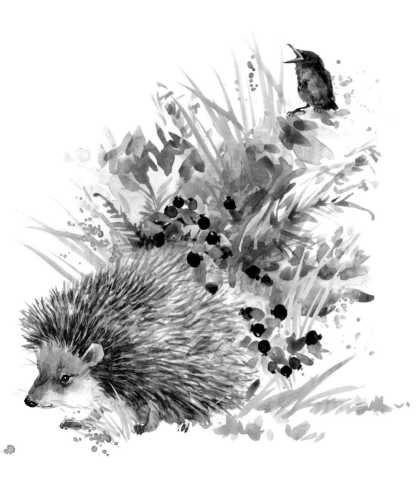

"There are only
two tragedies in life:
one is not getting
what one wants,
and the other is getting it."

– OSCAR WILDE

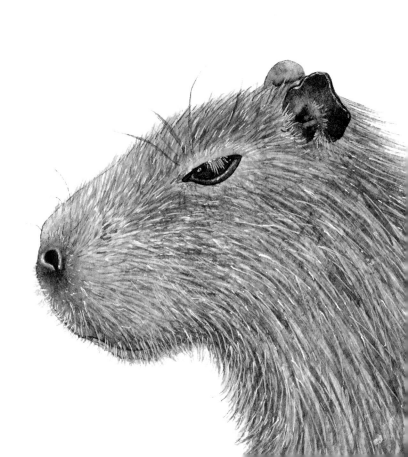

"*We must go beyond textbooks, go out into the bypaths and untrodden depths of the wilderness and travel and explore and tell the world the glories of our journey.*"

– JOHN HOPE FRANKLIN

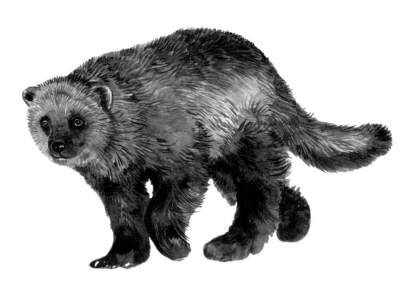

"The Arctic is among the least understood places on the planet; however, we do know that its landscape is changing and evolving as quickly as cell phones and the Internet."

– PHILIPPE COUSTEAU, JR

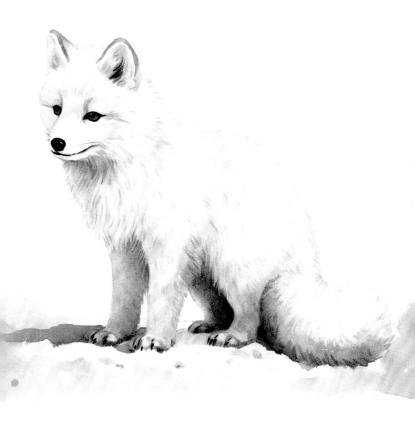

"A bear, however hard
he tries, grows tubby
without exercise."

– A. A. MILNE

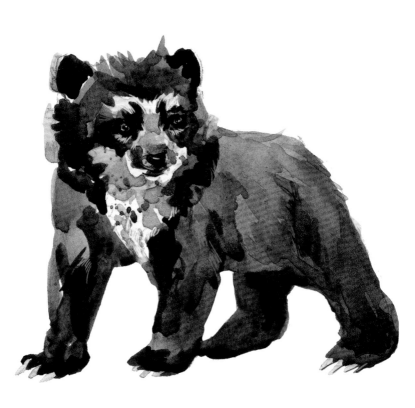

"*Reminds me of my safari in Africa. Somebody forgot the corkscrew and for several days we had to live on nothing but food and water.*"

– W. C. FIELDS

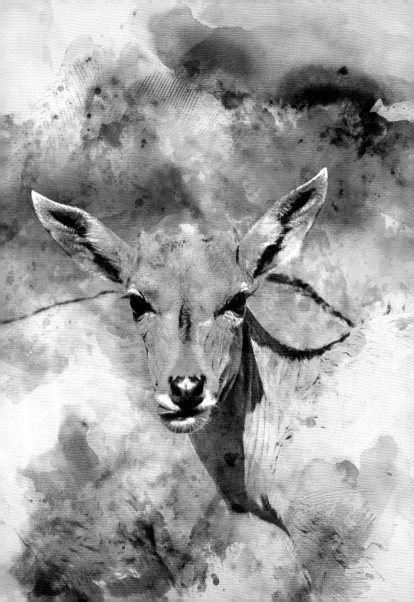

"Sometime during the many millions of years that have elapsed since mammalian faunas came into existence, some sort of island crossed from West Africa to South America."

– LOUIS LEAKEY

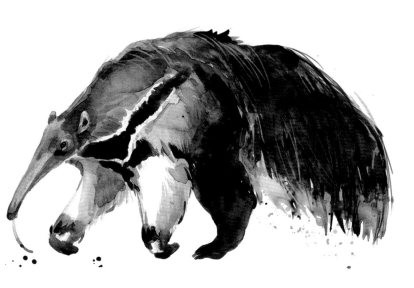

"The eyes like sentinel occupy the highest place in the body."

– MARCUS TULLIUS CICERO

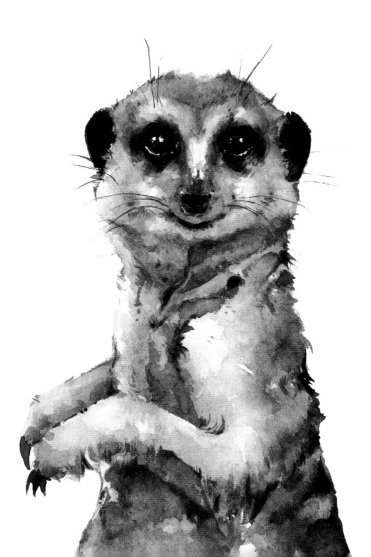

"*Living next to you is in some ways like sleeping with an elephant. No matter how friendly and even-tempered is the beast, if I can call it that, one is affected by every twitch and grunt.*"

– PIERRE TRUDEAU

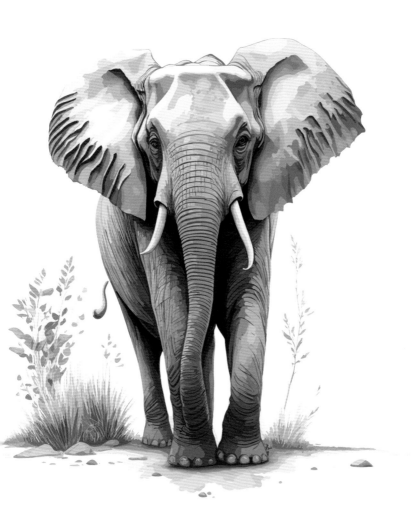

"I've cheated the Grim Reaper more times than anyone I know, and I'll fight like a wildcat until they nail the lid of my pine box down on me."

– EDDIE RICKENBACKER

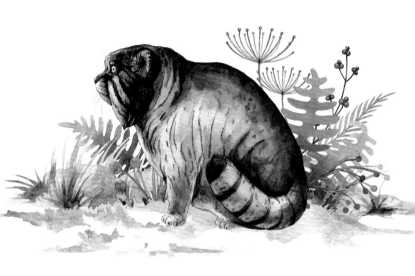

"*The rage of a wild boar is able to spoil more than one wood.*"

– GEORGE HERBERT

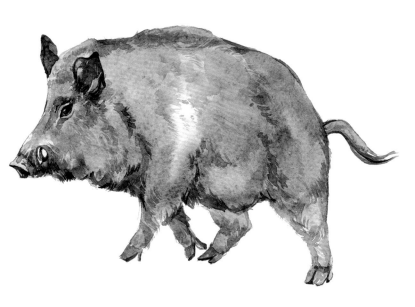

"Just cause you got the monkey off your back doesn't mean the circus has left town."

– GEORGE CARLIN

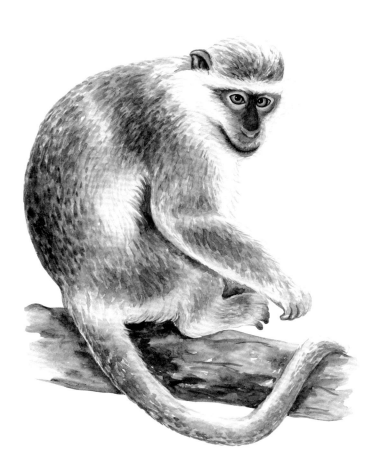

"When you are about to die, a wombat is better than no company at all."

– ROGER ZELAZNY

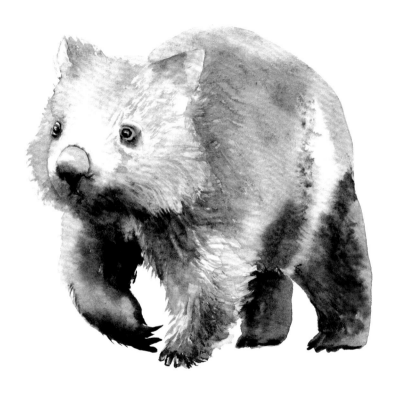

"You're making me feel like
a skunk at the garden party."

– KEN STARR

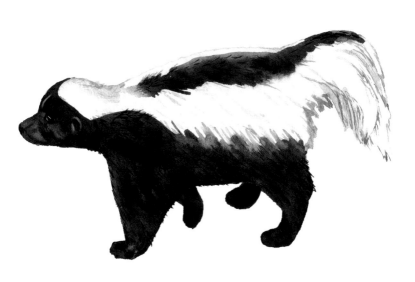

"*Know thy self,
know thy enemy.
A thousand battles,
a thousand victories.*"

– SUN TZU

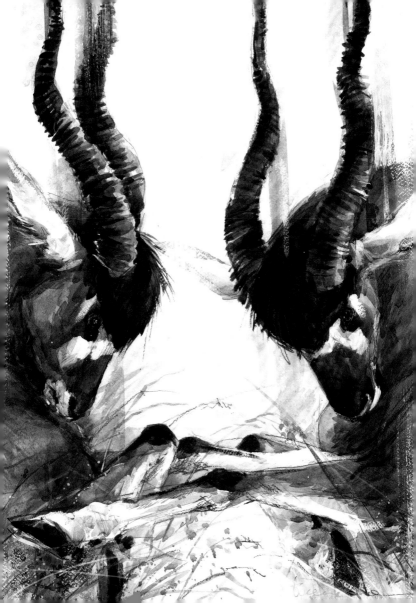

"I'll tell you what hermits realise. If you go off into a far, far forest and get very quiet, you'll come to understand that you're connected with everything."

– ALAN WATTS

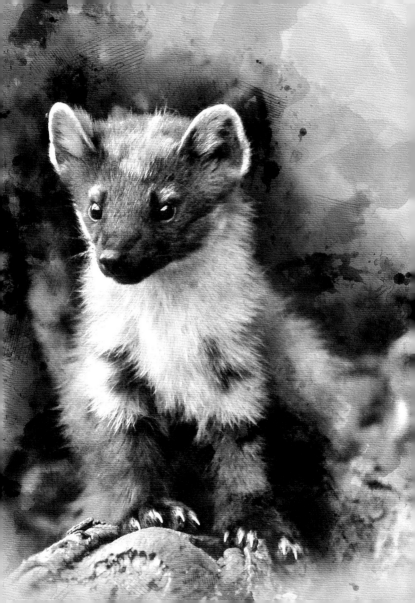

"It's so off the charts and off anybody's radar screen, that place. It might as well be another planet. Just try to find somebody who's been to Madagascar. Nobody has been to Madagascar."

– DAVID DOUGLAS

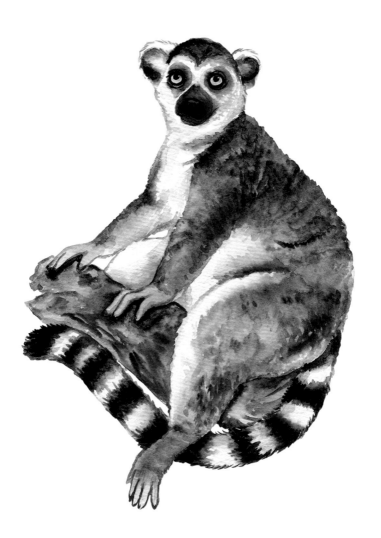

"All of us involved say The Dick Van Dyke Show was the best five years of our lives. We were like otters at play."

– DICK VAN DYKE

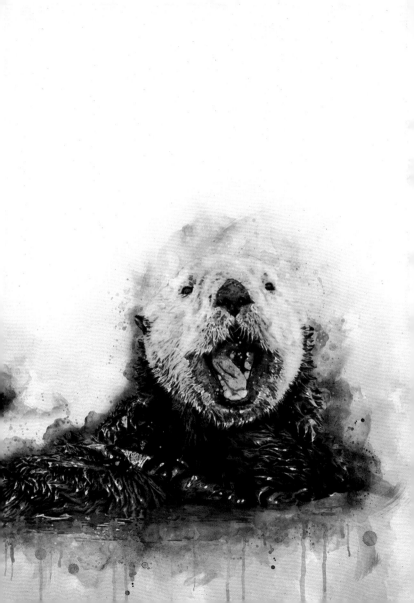

"*What joy when the insouciant armadillo glances at us and doesn't quicken his trotting across the track into the palm brush. What is this joy? That no animal falters, but knows what it must do?*"

– DENISE LEVERTOV

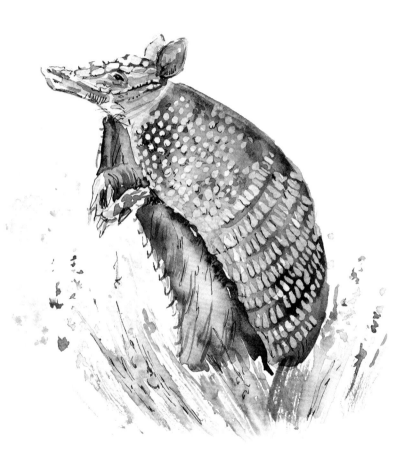

"When red-haired people are above a certain social grade their hair is auburn."

– MARK TWAIN

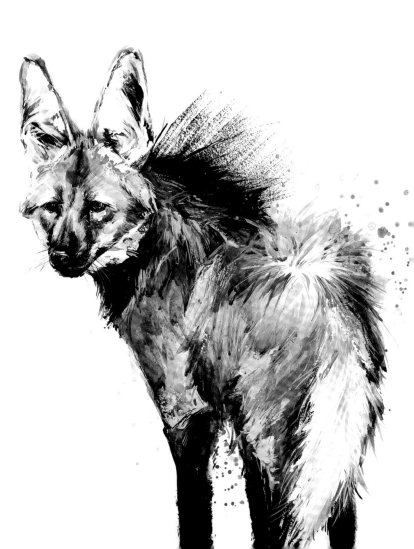

"A moose is an animal with horns on the front of its head and a hunting lodge wall on the back of it."

– GROUCHO MARX

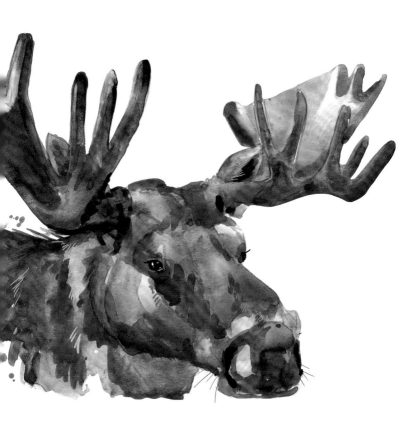

"I was in a bar the other night, hopping from barstool to barstool, trying to get lucky, but there wasn't any gum under any of them."

– EMO PHILIPS

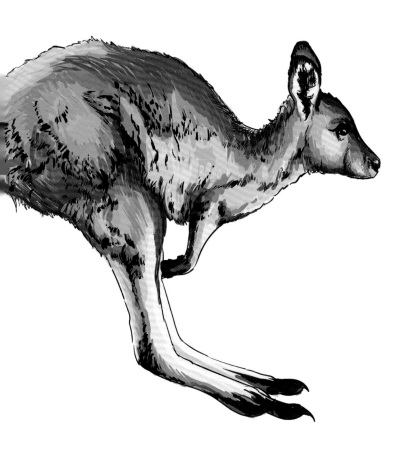

"*Perfection is attained
by slow degrees;
it requires the hand of time.*"

– VOLTAIRE

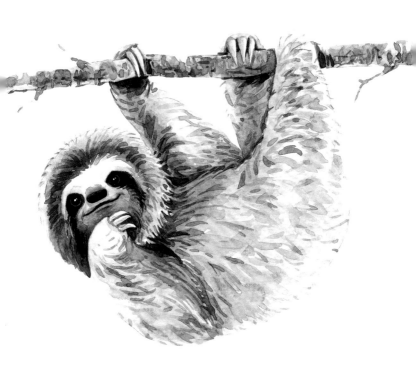

"No other creatures of the savannah sleep as deeply or as soundly as lions, but after all, lions are the main reason for not sleeping soundly."

– ELIZABETH MARSHALL THOMAS

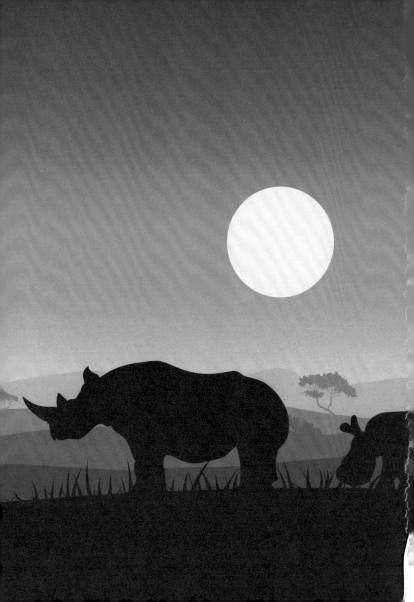

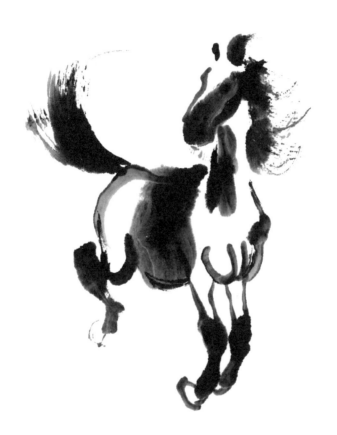

Published in 2024 by Reed New Holland Publishers
Sydney

Level 1, 178 Fox Valley Road, Wahroonga, NSW 2076, Australia

newhollandpublishers.com

Copyright © 2024 Reed New Holland Publishers

Copyright © 2024 in images: Shutterstock.com

ISBN 978 1 76079 622 8

Managing Director: Fiona Schultz
Publisher and Project Editor: Simon Papps
Designer: Andrew Davies
Production Director: Arlene Gippert

Printed in China

10 9 8 7 6 5 4 3 2 1

OTHER TITLES BY REED NEW HOLLAND INCLUDE:

Chris Humfrey's Awesome Australian Animals
Chris Humfrey
ISBN 978 1 92554 670 5

Encyclopedia of Australian Animals
Martyn Robinson
ISBN 978 1 92158 054 3

Strahan's Mammals of Australia **(Fourth Edition)**
Andrew Baker and Ian Gynther (Editors)
ISBN 978 1 92554 675 0

Urban Wildlife of Australia
Fold-out ID card
ISBN 978 1 92107 375 5

World of Mammals
ISBN 978 1 92554 660 6

For details of these books and hundreds of other Natural History titles see
newhollandpublishers.com and follow ReedNewHolland and NewHollandPublishers on Facebook

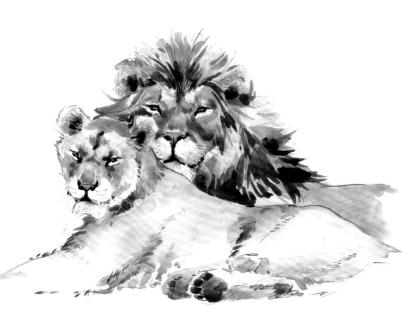